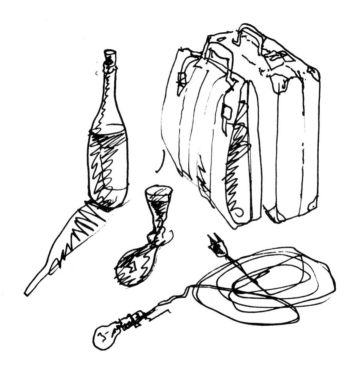

Small glass Testing kit : from.
 late Summer 1983 pre Serpentine

Bill Culbert Selected Works 1968 — 1986

An ICA publication to coincide with an exhibition of recent works, 28 May—29 June 1986.
In association with the Orchard Gallery, Londonderry; Cornerhouse, Manchester; and Victoria Miro Gallery,
London; to accompany exhibitions at these galleries in 1986 and 1987.

The work of Bill Culbert is surrounded by the manufacturing world of functional objects, mostly from France, where he has lived and worked over the last twenty-five years. This would include the 2CV car and its parts, the products of glass and electricity, and domestic ware. His perception of this world also carries with it a preference for the design styles of the nineteen forties and fifties, with their round cornered quadrilaterals and triangles, the flying wedges of coffee tables and the first glimpse of a space age. To this could be added the awareness and possibilities of the 'habitants-paysagistes', as located and documented by the landscapist Bernard Lassus, and the improvisations of the local village 'garagist'.

His work celebrates a world of ordinary objects and the place in it for a new art derived from them. It demonstrates to us a resourcefulness to exist from the found discarded objects of the material world, and its delight is in the bricolage of their re-usage. In this lies its moral.

He utilises a succession of objects which will provide light from electricity. From table to wall to the ceiling and onto the floor, they both help us to see, but also manifest their own particular nature. It is in this fusion of purpose and playfulness that the invention of Bill Culbert arises.

The used objects from which he makes the work are often in a continuing state of repair, from their discardedness to their re-arrangement in what will be considered a final work. Even their very brokeness has at times been used as part of the work itself; re-viewed in this way the patchwork of blemishes on the enamel jug and bowl of *'Dalmation, 1981'* create their own metaphoric point.

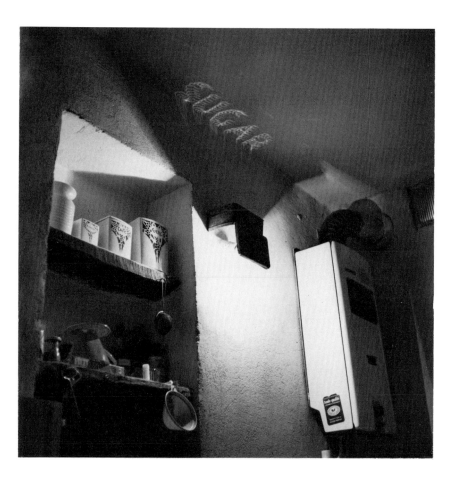

A jug is also a table lamp pouring its spilt light, and jugs can form ubiquitous patterns of flight across the parlour wall. A table lamp is also the room itself with the bulb suspended from the ceiling, and now a column of tables with light running through them to form a lighthouse. A row of white translucent detergent containers, connected and irradiated by a fluorescent tube is poetically described as *'Long White Cloud, 1985'*. Similar yet differently coloured containers connected in the same way and held at each end by a coat peg could be described as wall lights.

A lunch box announces itself as a constellation of projected filaments, as does the indented lid of a box of sugar cubes. Such works of camera obscura, have always been an important aspect of Bill Culbert's work, and may have started with the perception of the simple perforations in a lampshade producing a patterned corner to the room. A pin-hole perforation magnifies the filament of a clear tungsten light bulb and at the same time projects it to the nearest surface.

A culminatory aspect of the work has arisen from the discovery and realisation that through the correct weight and density of bistro wine glass, red wine is both solid enough to cast its own shadow and to refract the filament at the centre of the electric light bulb. This was the beginning of the work *'Small Glass, Pouring Light'* from 1983, which was shown in London, Paris and New York during that year. The installed work can only be completed by its use as a table of drinking glasses, for the simplest sort of curatorship of the work is to drink the wine, and thereby prevent an accumulation of dust from soiling its immaculate surface. By such an act, it becomes an ordinary part of our life, yet at the same time a transition of mysterious significance is taking place in front of us continuously.

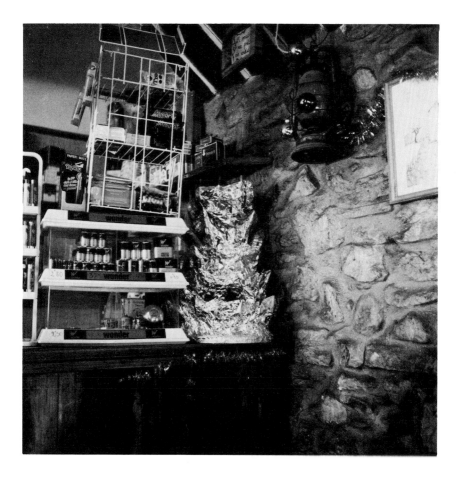

The ongoing 2CV series consists of paintings from 1960, objects and photographs. As with the previous work, and the photo-book produced in 1984, the photograph is at times a work in its own right, and at times a contextual reference to other work and sources. The 2CV objects are formed from parts of the car; headlamps become chandeliers and standard lamps, and they are also replaced at exactly the right height and distance apart in a room, shining outwards towards the street. Hub-caps become furniture, and the windscreen is used for the back of a chair.

Someone's Christmas tree at the Cafe Regain, Revest de Brousses, in 1980, is in fact Marcel Duchamp's bottle rack covered in silver foil for the occasion.

Simon Cutts

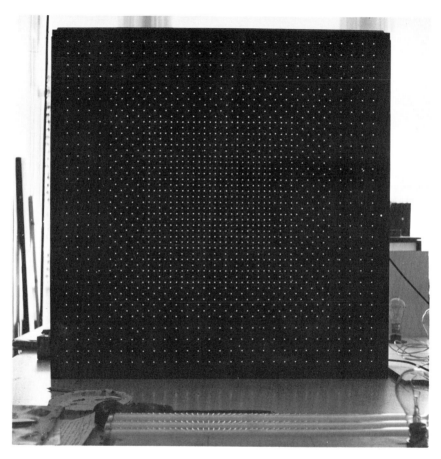

Light Field I 1968
A black metal box containing light, revealed by a system of drilled holes (diameter one sixteenth of
an inch).
76 × 76 × 10 cms
First shown Onnasch Galerie, Berlin 1969

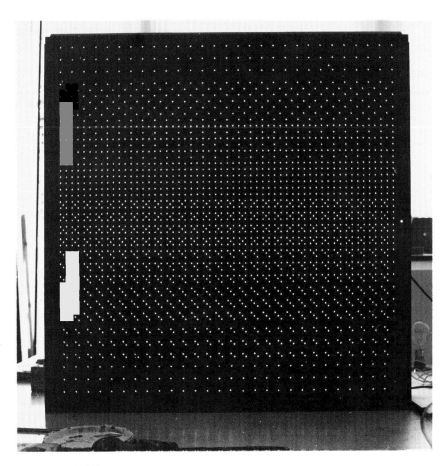

Light Field II 1968

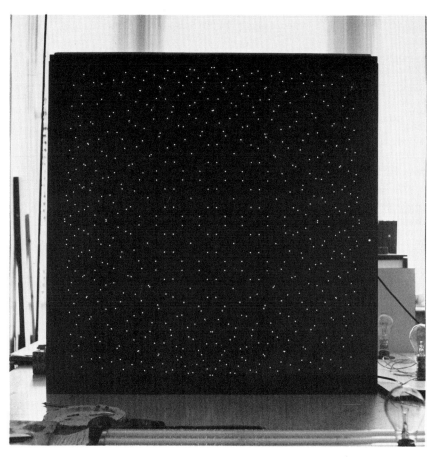

Light Field III 1968

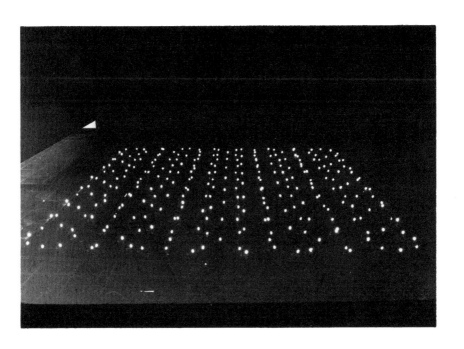

Light Field, Blaze 1968
Two systems of small light bulbs, the wiring woven into a mesh fabric, forming a square grid and a diamond-shaped grid. Lit seperately and then together.
274 × 274 cms
First shown Forum Kunst, Rottweil, West Germany 1976

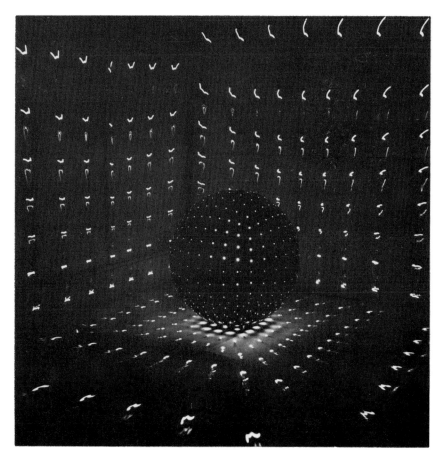

Cubic Projections 1968
A black fibreglass sphere containing a single 150 watt bulb at the centre. The image of the light
filament is projected through a system of drilled holes in the manner of a camera obscura.
Diameter 64 cms
First shown Camden Arts Centre, London 1968

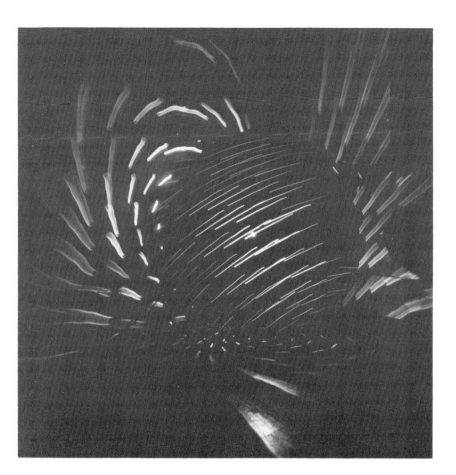

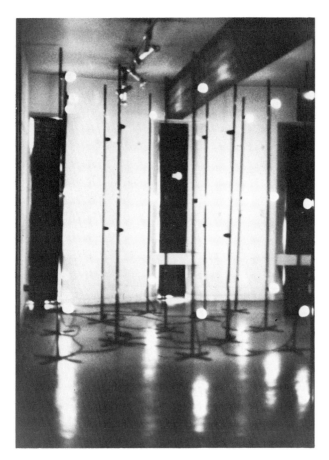

Light Station 1969
An arrangement consisting of three systems of lights on 13 metal poles. The centre pole has a single 150 watt bulb, four poles form a square around the central pole and each has two 25 watt bulbs, the eight outer poles have three 15 watt bulbs each. A time switch allows each of the three systems to be lit for five seconds at a time. The overall strength of light remains approximately constant.
274 × 274 × 274 cms
First shown Greenwich Theatre Gallery, London 1969

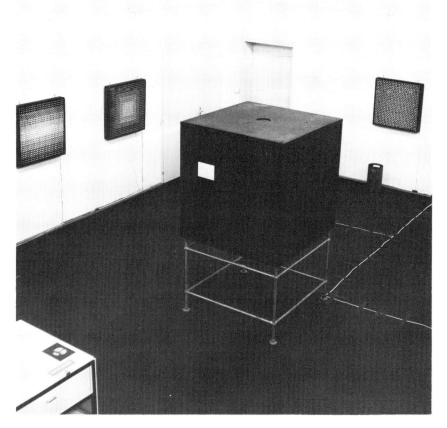

Black Box 1969
A box containing six systems of lighting, one on each interior surface. The wiring arrangement for each system being visible on the exterior. A time switch lights each system in turn, the evidence being the sound of the switching and the warmth of the surfaces.
122 × 122 × 122 cms on a metal stand
First shown Camden Arts Centre, London 1969

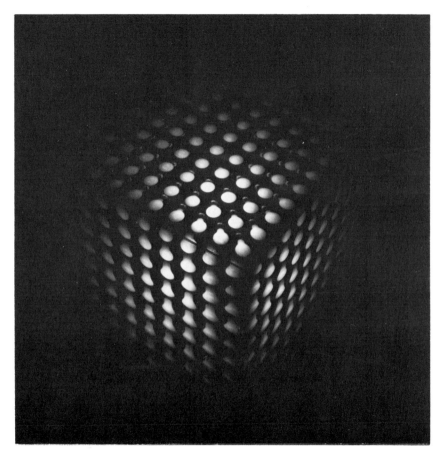

Celeste 1970
A translucent perspex cube containing a single 60 watt white mushroom-shaped light bulb in a metal box. The box is drilled with a system of holes which project the image of the bulb onto the perspex in the manner of a camera obscura.
33 × 33 × 33 cms
First shown Forum Kunst, Rottweil, West Germany 1976

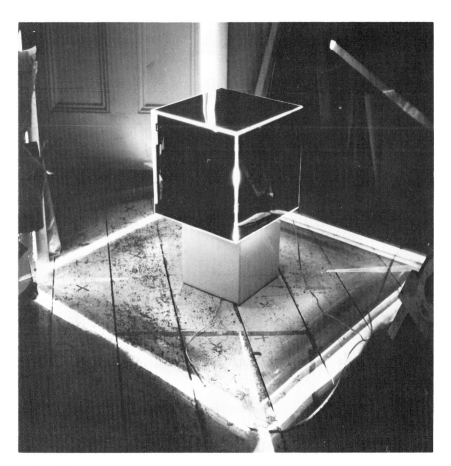

Outline 1970
A black perspex cube constructed so as to leave a sixteenth of an inch gap on all edges. Containing a single 60 watt light bulb to project the lines of a cube, in the manner of a camera obscura.
30 × 30 × 30 cms
First shown Forum Kunst, Rottweil, West Germany 1976

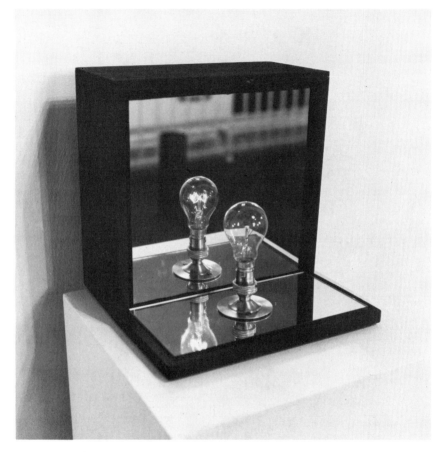

Reflection II 1975
A black box, one side being a two-way mirror, containing a lit bulb adjacent to an unlit bulb and
holder on the exterior mirrored ledge. The two-way mirror reflects the unlit bulb and holder as
well as revealing the lit filament of the bulb inside the box.
33 × 33 × 33 cms
First shown Forum Kunst, Rottweil, West Germany 1976

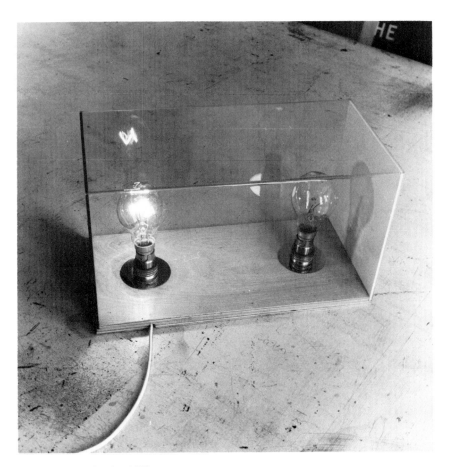

Shadow and Reflection 1975
A perspex box on a wooden base, containing two light bulbs and holders. The lit bulb reflects in the black perspex end panel and casts the shadow of the unlit bulb onto the white end panel.
18 × 19 × 35 cms
Limited edition produced by Forum Kunst, Rottweil 1976

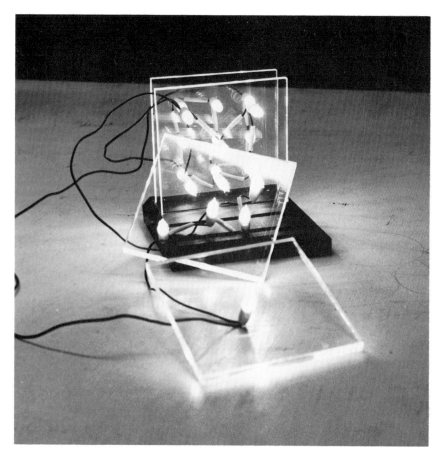

Dice Cube 1970
Four perspex plates detachable from a wooden slotted base but attached to each other by the wiring system for one, three, five and nine small bulbs.
10 × 10 × 10 cms

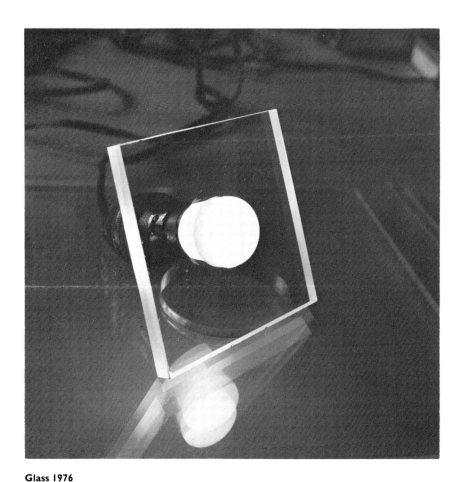

Glass 1976
A crystal slab with a chamfered hole cut to hold a 25 watt bulb. Because of the clarity of the crystal, when the bulb is lit the crystal seems to disappear.
15 × 15 × 15 cms

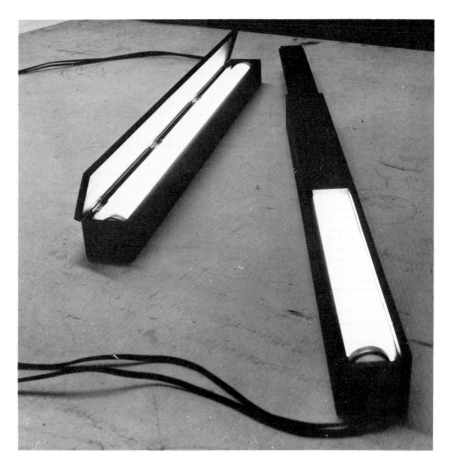

Lift and Slide 1972
Two wooden boxes, one with a hinged lid, the other a sliding lid, each containing a fluorescent
tube. When the lids are closed no light is visible from within.
62 × 5.5 × 5.5 cms

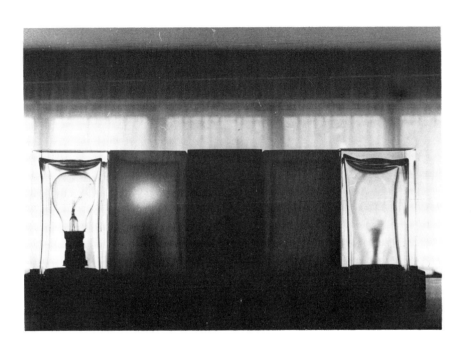

Daylight to Nightlight, Five Cubes to Black 1976
Five crystal forms, two clear, two translucent and one black (made in Wolfach, West Germany
1980). The clear, translucent and black cubes from the left contain a lit 10 watt bulb.
50 × 16 × 10 cms
Perspex version shown Serpentine Gallery, London 1977

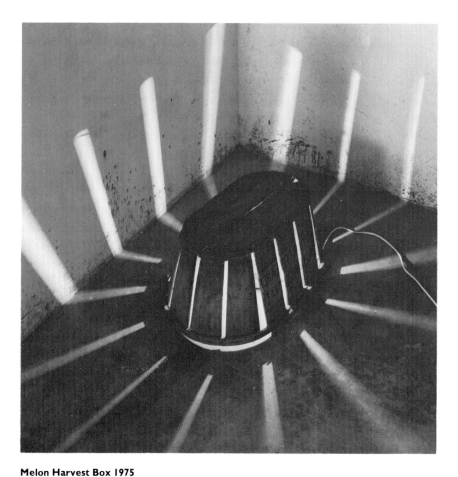

Melon Harvest Box 1975
A wooden box with a light inside.
$60 \times 40 \times 30$ cms
A fruit box with a light inside was shown in Forum Kunst, Rottweil, West Germany 1976

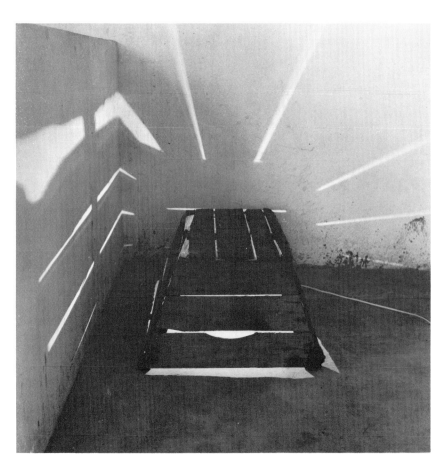

Grape Harvest Box 1975
80 × 50 × 30 cms

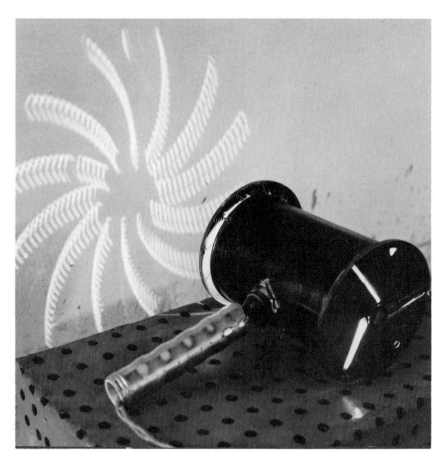

Tumble 1972
A coffee tin, a bicycle pump handle and two shredders from a rotary vegetable cutter. The tin
contains a single bulb and projects in two directions. When rolled, the projection of the filament
tumbles in the manner of a three-dimensional camera obsura.
12 × 18 × 25 cms

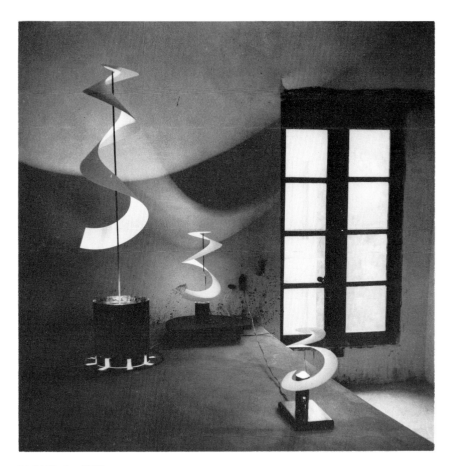

Light Vortex 1975
Three card mobiles suspended on rods, that turn with the heat from a light bulb in each base.
heights 150, 70 and 40 cms

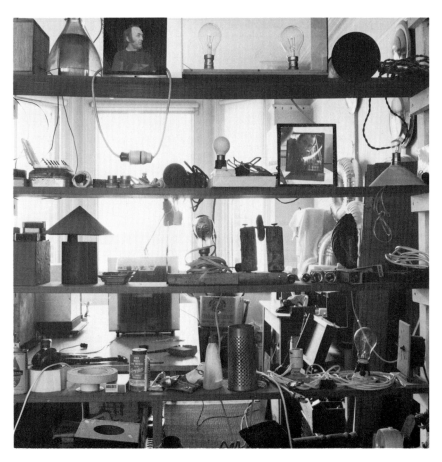

Storage shelves dividing studio, east and west views.
London 1976

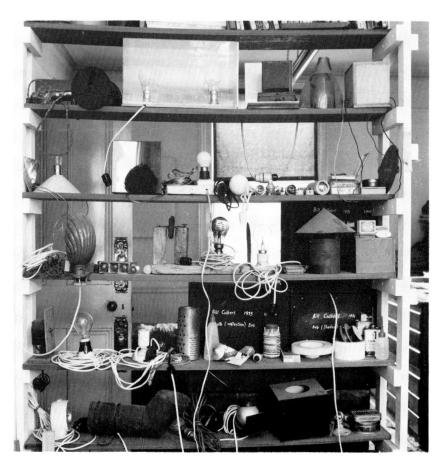

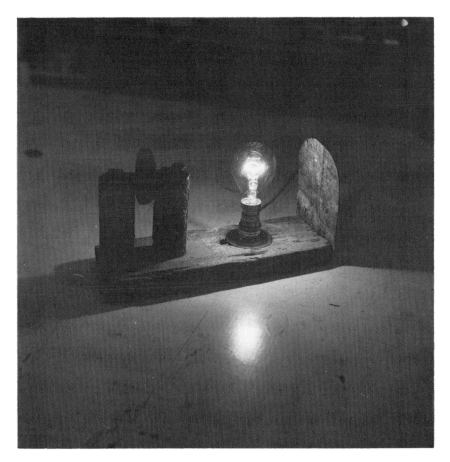

Wheel Works 1972
A found wooden object with a suspended wheel and a metal end, fitted with a coil indicator light
bulb and holder, the spiral filament glows red.
30 × 20 × 18 cms
First shown Serpentine Gallery, London 1976

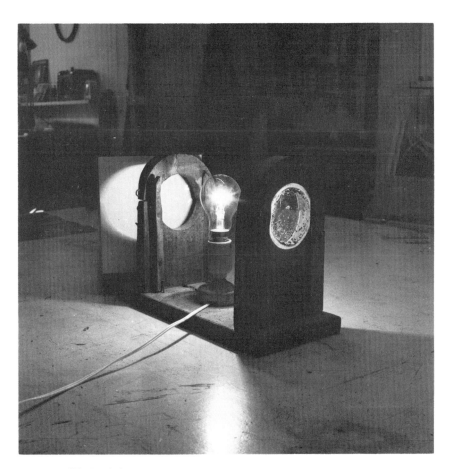

Asparagus Works 1973
A 1 kilo asparagus bundler that is used to trim the ends of a bundle of asparagus to the same length,
the light bulb projects the marks left on the glass end by the asparagus tips.
35.5 × 25.5 × 15 cms
First shown Serpentine Gallery, London 1976

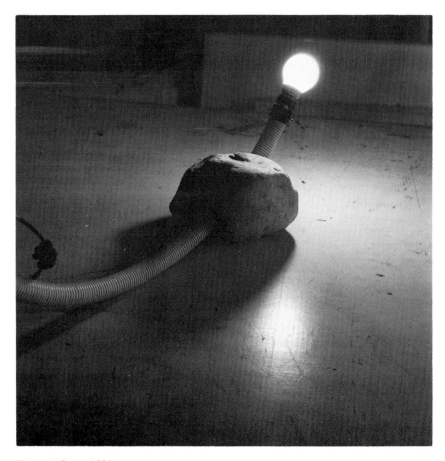

Through Stone 1974
A found stone with a hole, plastic concertina tubing and cable with a 25 watt bulb.
35.5 × 18 × 20 cms
First shown Serpentine Gallery, London 1976

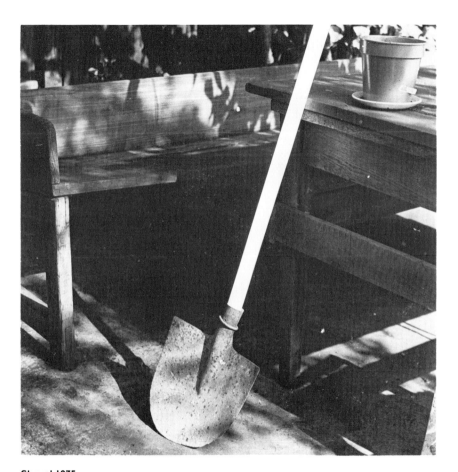

Shovel 1975
A shovel with a fluorescent tube.
4 foot tube

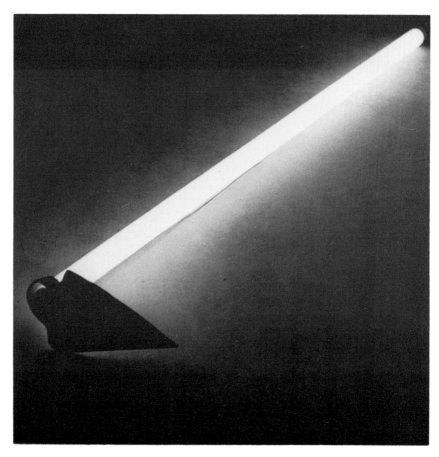

Triangular Hoe 1976
A hoe with a fluorescent tube.
4 foot tube

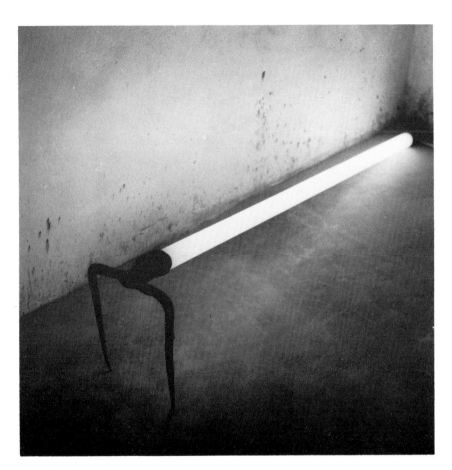

Two Prong Fork 1976
A fork with a fluorescent tube.
4 foot tube

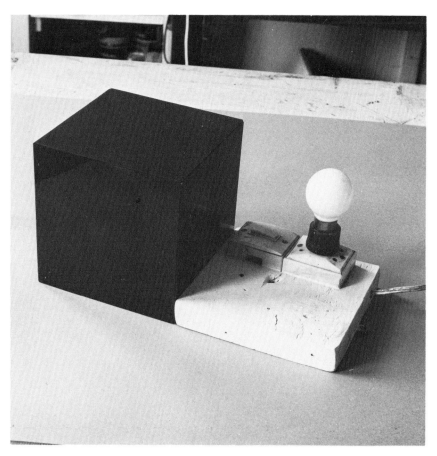

Black Box with Switch 1976
A black perspex box containing a small light bulb identical to the indicator bulb adjacent to the switch outside.
31 × 15 × 15 cms
First shown Serpentine Gallery, London 1976

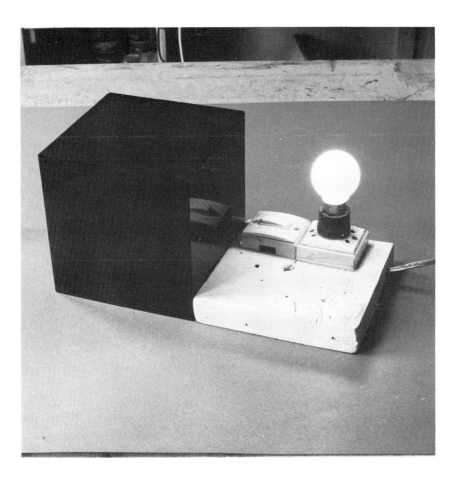

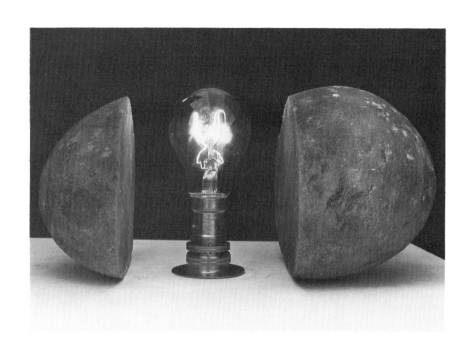

Moonlight Creek II 1978
A stone found in Moonlight Creek, an old gold-dredging river on South Island, New Zealand.
Precision cut by exposure to frost. Mounted on a wooden base with a lit bulb and brass holder.
38 × 30 × 20 cms
Made and shown in New Zealand

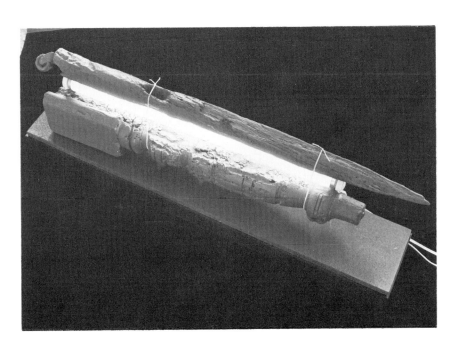

Murdering Beach 1978
A table leg and tea trolley leg found on Murdering Beach, near Port Chalmers. Bound together
with a fluorescent tube. Exhibited in a perspex box, the heat from the starter causing condensation
in the form of a mist or shroud.
70 × 18 × 18 cms
Made and shown in New Zealand

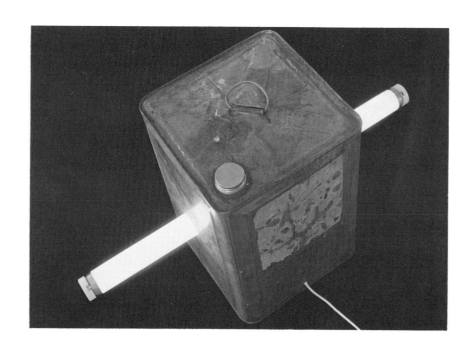

Blackball to Roa 1978
The title comes from two small villages on the West Coast of South Island, New Zealand, the latter
no longer existing. A Kerosene can traversed by a fluorescent tube.
35 × 24 × 24 cms
Made and shown in New Zealand

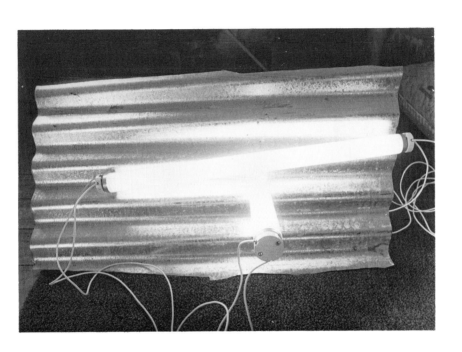

Blackwater also Southern Cross 1978
A sheet of corrugated iron supported at an angle by a fluorescent tube passing through it, another tube crosses the supporting tube parallel to the corrugations. Blackwater is a small mining community where corrugated iron has been the principal building material since the 19th century.
2 foot tubes
Made and shown in New Zealand

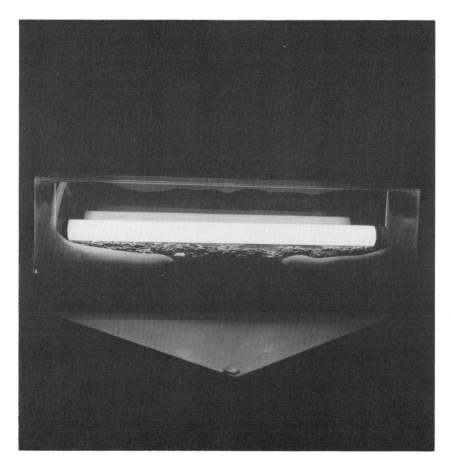

Reefton, Cloud 1978
A two-foot fluorescent tube placed on a piece of charred, burnt wood enclosed in a perspex box.
Reefton is now a small town, surrounded by much devastation of the native forests. As in
Murdering Beach the starter causes condensation inside the box.
66 × 18 × 15 cms 1978
Made and shown in New Zealand

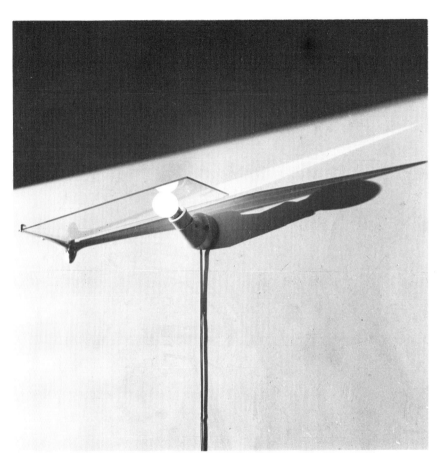

Glass Shelf 1979
A glass bathroom shelf supported by a chrome bracket and a small lit bulb with a porcelain fitting.
45 × 12.5 cms
First shown Acme Gallery, London 1979

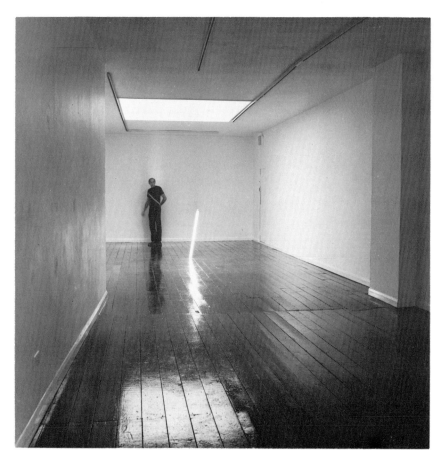

Through Light 1979
An eight-foot fluorescent tube passing at a slight angle through the floor upstairs to the ceiling downstairs.
Installation: Acme Gallery, London 1979

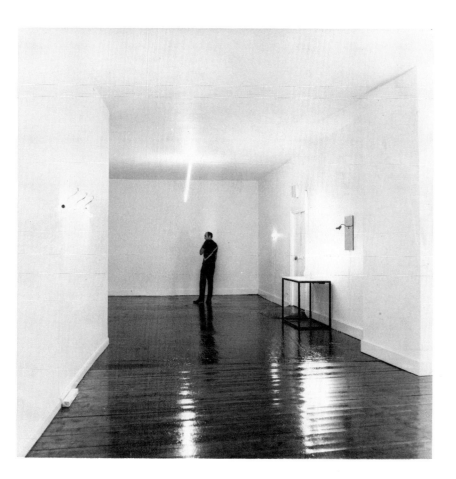

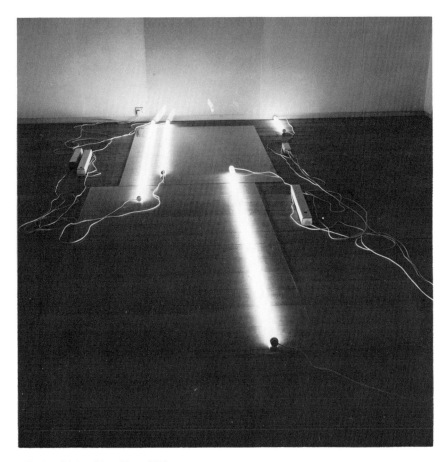

Window Light, Glass Floor 1980
An installation made in an upstairs gallery with no natural light and all existing lighting removed.
Consisting of glass sheets laid on the floor with fluorescent tubes placed on top. Glass sheets leant
against the walls reflect the floor lighting.
Sunderland Arts Centre 1980

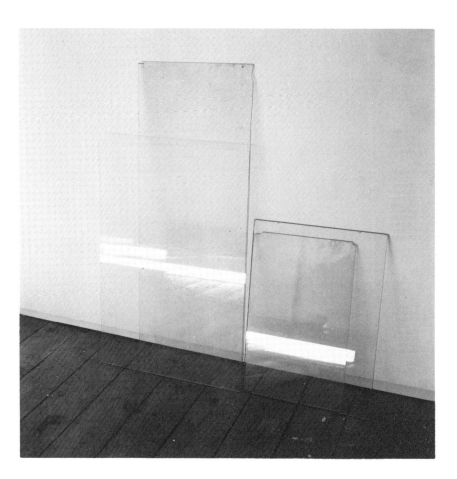

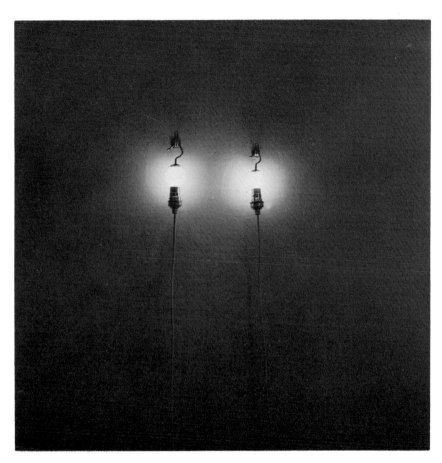

Light Hooks 1979
14 × 4.5 cms
First shown Acme Gallery, London 1979

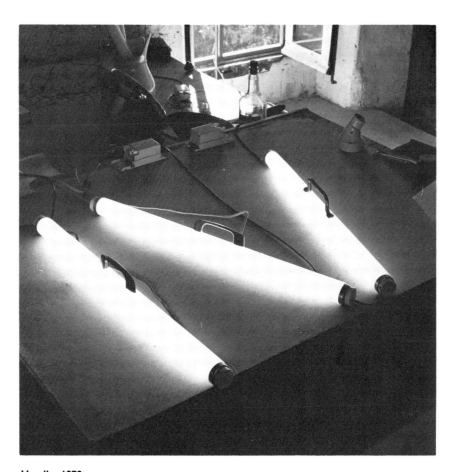

Handles 1979
Black plastic, chrome and iron handles attached to fluorescent tubes.
2 foot tubes
First shown Acme Gallery, London 1979

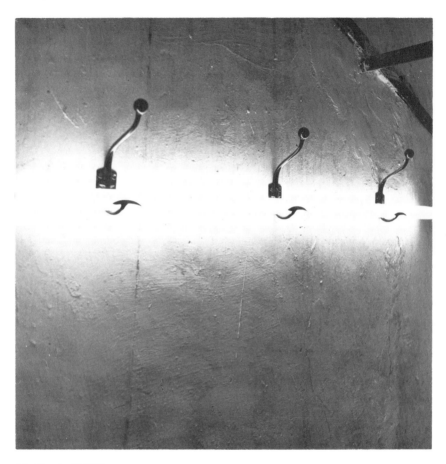

Coathooks III 1979
Three metal coathooks supporting a five-foot fluorescent tube.
First shown Acme Gallery, London 1979

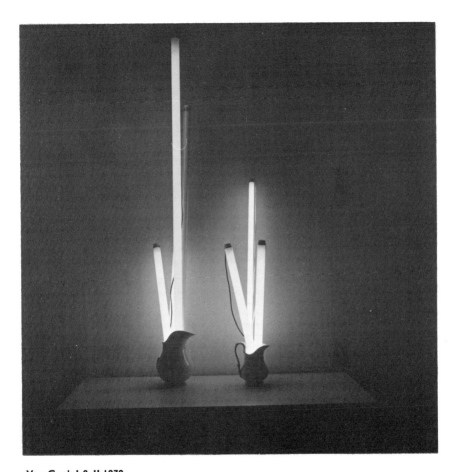

Van Gogh I & II 1979
Fluorescent tubes in two white porcelain jugs (one with a broken handle).
92 × 122 cms
First shown Acme Gallery, London 1979

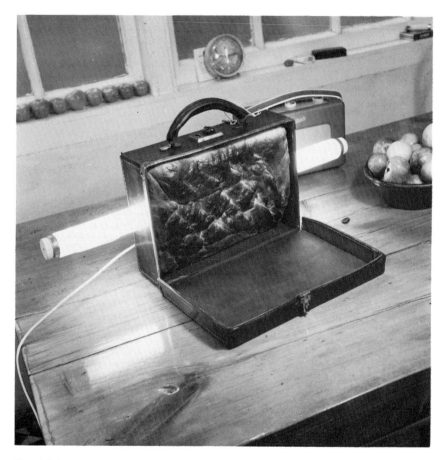

Bread Suitcase 1977
A loaf of bread baked in a dish built especially to fit the suitcase. The loaf contains the starter unit for the fluorescent tube. When lit the loaf glows the colour of a sunset.
30 × 20 × 8 cms
Made for the Bread Exhibition, Forum Kunst, Rottweil, West Germany 1977

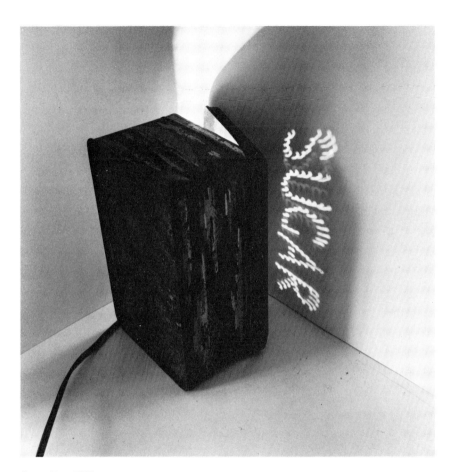

Sugar Box 1981
A painted metal French sugar box containing a light bulb and 'sugar' lettering punched in the lid.
Originally made as a kitchen light.
18 × 12 × 8 cms
First shown Coracle, London 1983

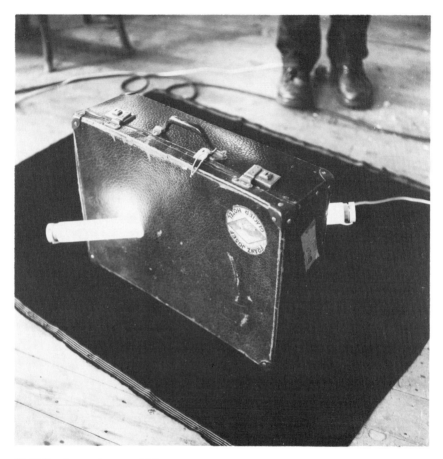

Hokitika, Return Journey 1978
A suitcase with a fluorescent tube passing through at an angle (South of Hokitika is a heavily glaciated area). The suitcase was bought in Hokitika on a second visit especially to purchase it.
52 × 36 × 15 cms
Made and shown in New Zealand

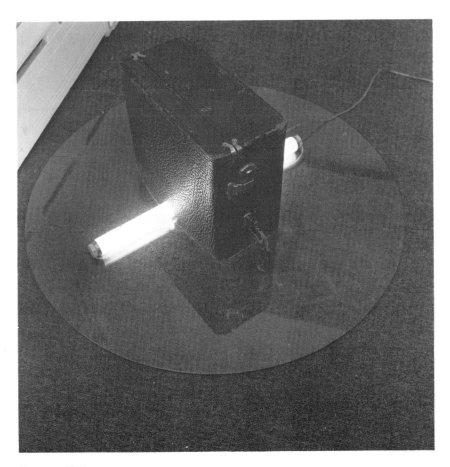

Steerage 1985
A suitcase found in Montreal, later halved and cut to hold a two-foot fluorescent tube and placed
on a three-foot diameter glass plate. The reflection in the glass completes the suitcase.
diameter 92 cms
Made in New York and first shown Barbara Toll Fine Art, New York 1985

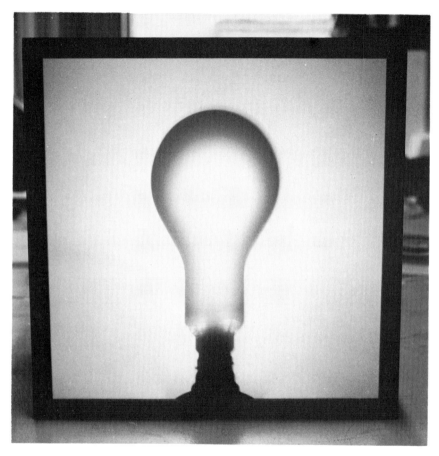

Bulb Box, Shadow I 1971
A black wooden box with a translucent perspex front panel. Containing two light bulbs, one dead and the other behind lit to project the dead bulb onto the perspex.
30 × 30 × 24 cms
First shown Serpentine Gallery, London 1976

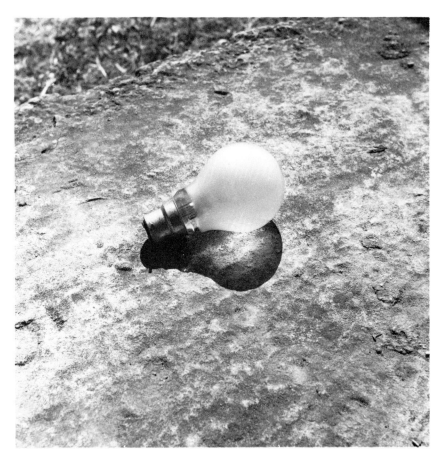

Frosted light bulb on stone, lit by the sun
France 1979

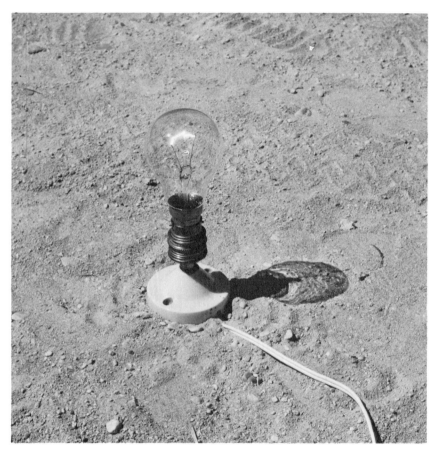

Light bulb and porcelain fitting, lit and with shadow projected by the sun onto dirt road.
France 1975

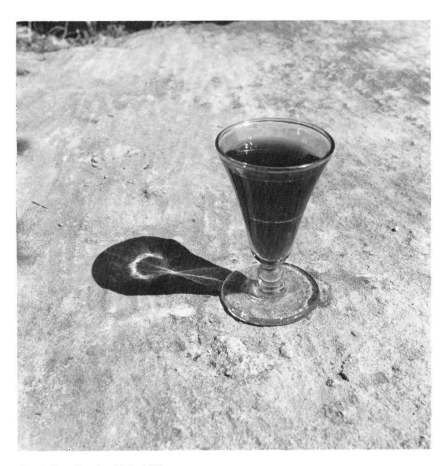

Small Glass Pouring Light 1979
A bistro glass with red wine in the sun.
France 1979, a hundred years since the invention of the light bulb.

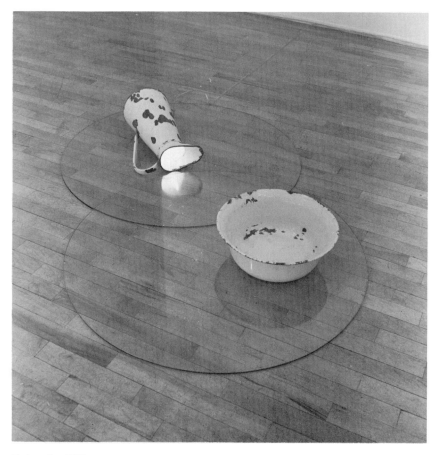

Dalmation 1980
Two overlapping circles of glass, with a white enamelled water jug and basin both chipped and marked, the jug lit by a small bulb inside.
3 foot glass circles
First shown Sunderland Arts Centre 1980

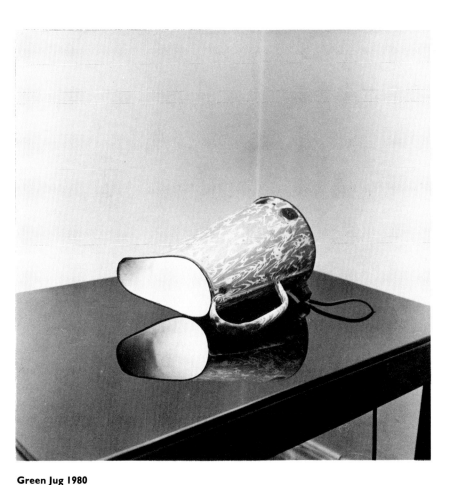

Green Jug 1980
A black enamelled table with a black glass top and a green enamelled jug, lit by a small bulb inside.
table 66 × 46 × 69 cms, jug 26 × 15 cms
First shown Sunderland Arts Centre 1980

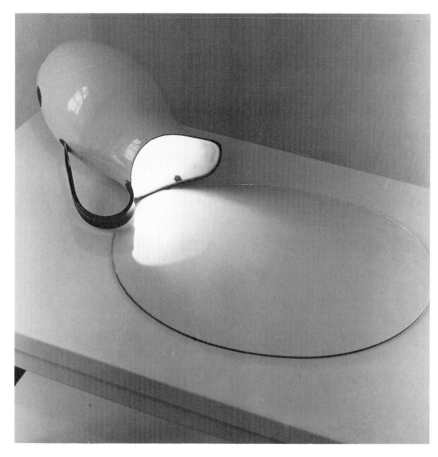

White Jug Pouring Light 1980
A white enamelled table with a glass oval and a white enamelled jug, lit by a small bulb inside.
table 66 × 46 × 69 cms, jug 26 × 15 cms, glass 30 cms
First shown Sunderland Arts Centre 1980

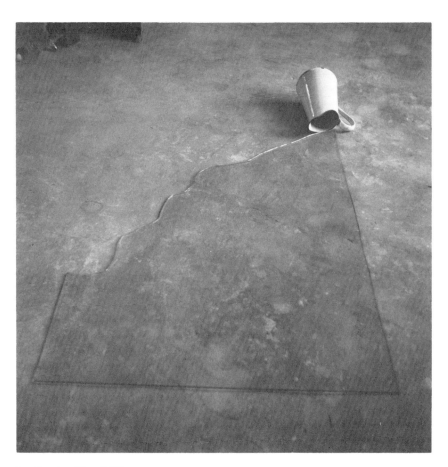

Jug Pouring Glass 1980
A white enamelled jug with a broken sheet of glass.
glass 100 × 80 cms

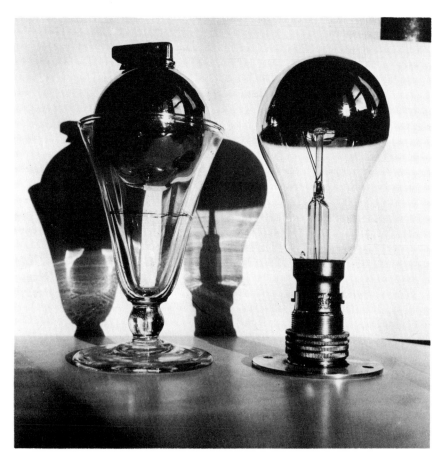

Bistro glass, light bulb, chrome lighter, brass bulb holder 1982.
16 × 16 × 7 cms

A wall projection of a colour slide with the objects in a small perspex box in front, at eye level
1982.

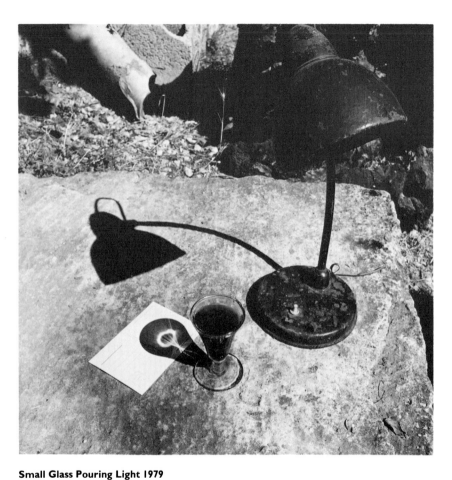

Small Glass Pouring Light 1979
The initial prototype photograph to illustrate the projection of the glass onto a white postcard.
gloss height 16 cms, diameter of rim 7 cms

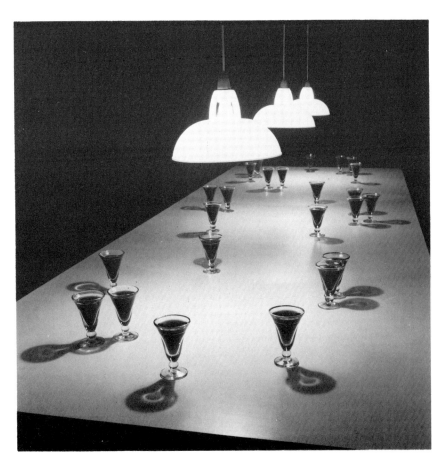

Small Glass Pouring Light 1983
A table covered in white formica, three hanging lamps and twenty-five bistro glasses containing red Vin du Table.
table 12 × 4 feet
Made for Electra, Musee de l'Art Moderne de la ville de Paris. Also shown in The Sculpture Show, Serpentine Gallery, London and Assemble Here, Coracle in New York, 1983

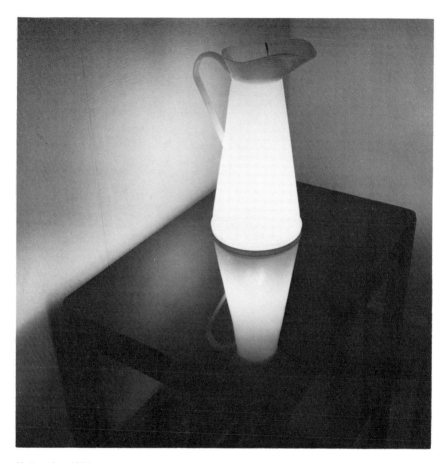

Yellow Jug 1984
A black enamelled table with a black glass top and a yellow plastic jug, lit by a small bulb inside.
table 66 × 46 × 69 cms
First shown Éric Fabre Galerie, Paris 1984

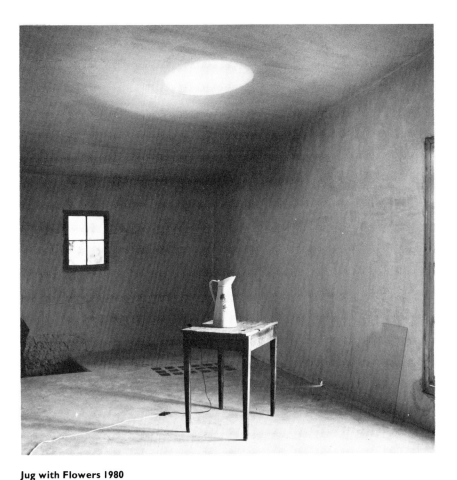

Jug with Flowers 1980
A grey enamelled table and an enamelled jug with flower prints, lit by a small bulb inside.
table 66 × 46 × 69 cms
First shown Sunderland Arts Centre 1980

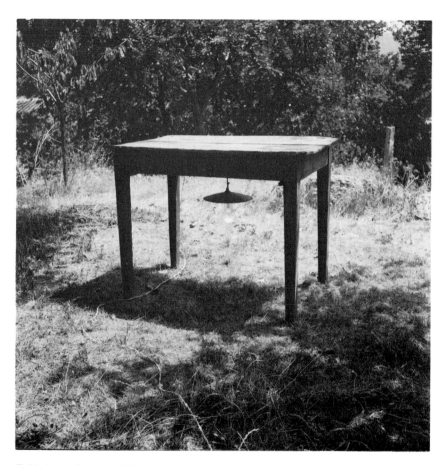

Table Lamp Exterior 1981
A wooden table with a green enamelled lampshade and a lit bulb.
92 × 61 × 56 cms

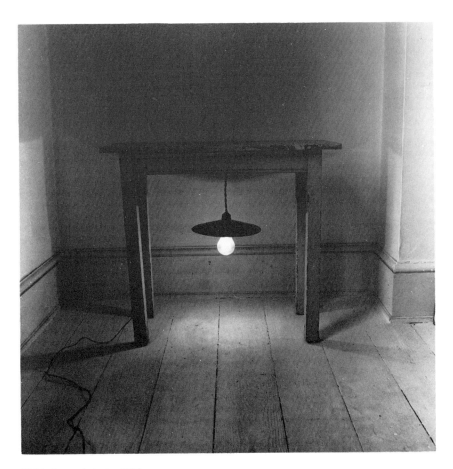

Table Lamp Interior 1982
A cream table with a blue/black enamelled lampshade and a lit bulb.
75 × 38 × 63 cms
First shown Winchester Art Gallery 1986

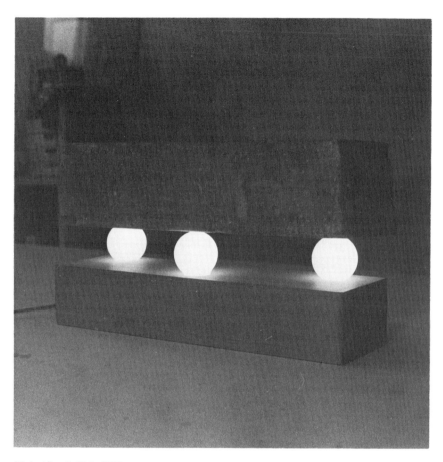

Light Lintel, Plain 1978
A marble block supported by three light bulbs on a wooden box base.
10 × 20 × 36 cms

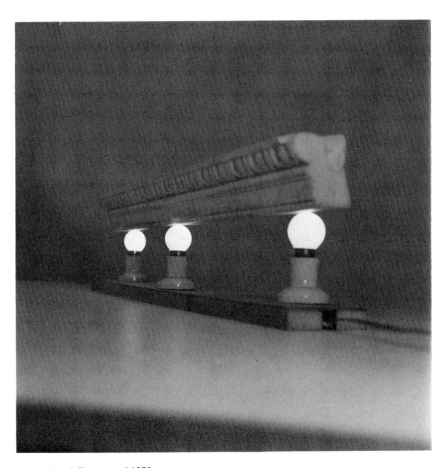

Light Lintel, Decorated 1979
A section of a marble lintel supported by three light bulbs and holders on a wood and perspex base.
11 × 20 × 82 cms

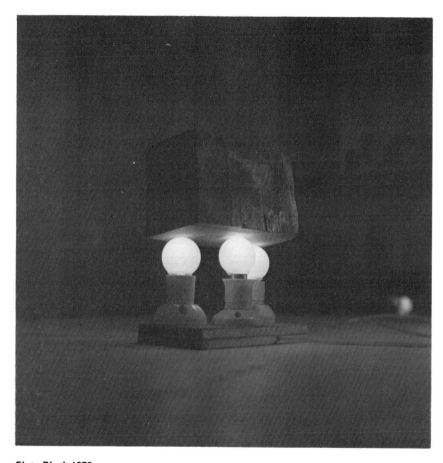

Slate Block 1978
A block of slate supported by three light bulbs and holders on a wood and perspex base.
30 × 30 × 23 cms

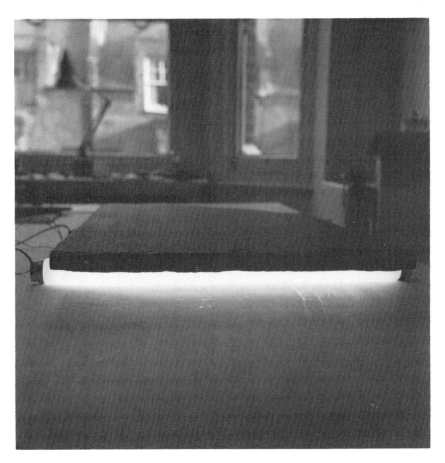

Slate Slab 1979
A slate slab supported by two two-foot fluorescent tubes.
$55 \times 40 \times 5$ cms

" Driving." Jan 1986 .

Yellow Headlights and Cut Stones 1986
2 CV headlamps and cut granite stones on the floor.
200×200 cms
First shown Atheneum, Dijon 1986

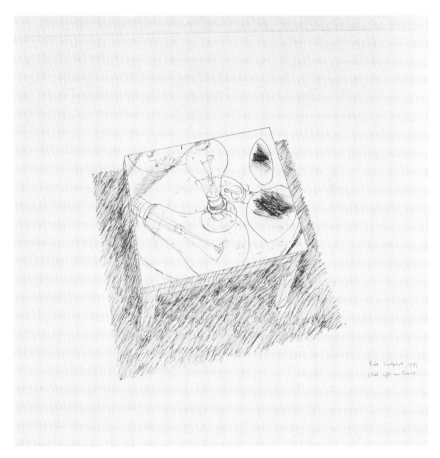

Still Life on Table 1981
Ink on paper.
60 × 40 cms

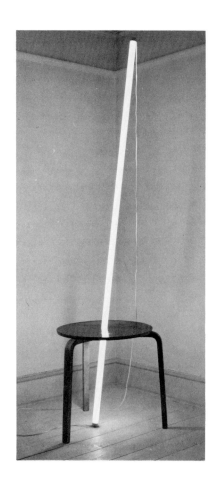

Table Lamp 1982
A natural wood table, with a red formica top coloured with black paint and an eight-foot
fluorescent tube.
First shown Coracle, London 1982

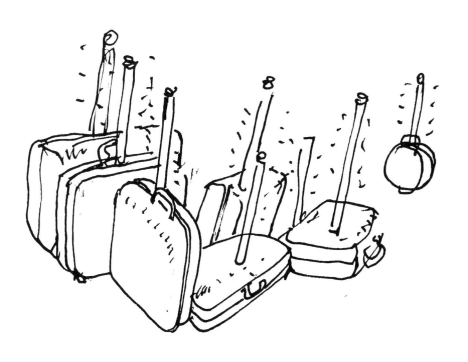

Travelling 1983
Five suitcases with three and five-foot fluorescent tubes.
First shown Assemble Here, Coracle in New York 1983

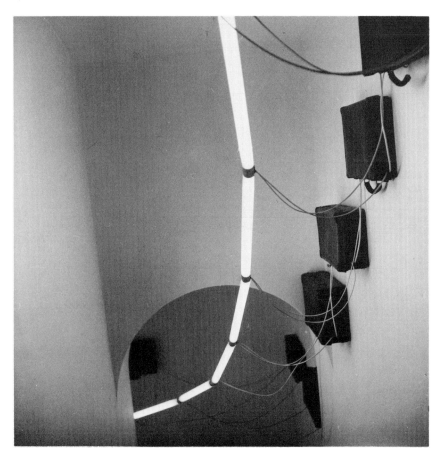

Night Passage 1983
Six four-foot and seven two-foot fluorescent tubes joined in a curve, passing through the ceiling angle and following the line of the staircase. The starters and chokes for each tube are contained in suitcases attached to the staircase walls.
Installation: Institute of Contemporary Art, London 1983

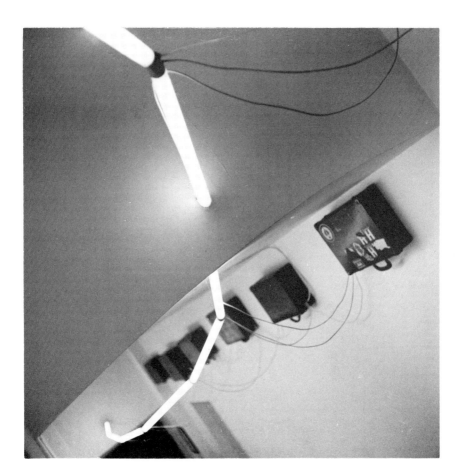

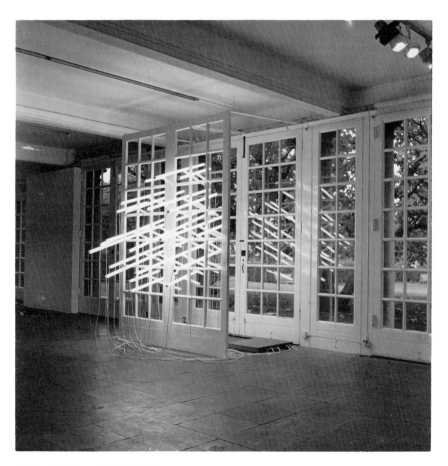

An Explanation of Light 1984
A replica of existing double window doors with twenty-one fluorescent tubes, two-foot to eight-foot tubes held in place by holes in the glass planes.
Installation: Salon d'Automne, Coracle at the Serpentine Gallery, London 1984

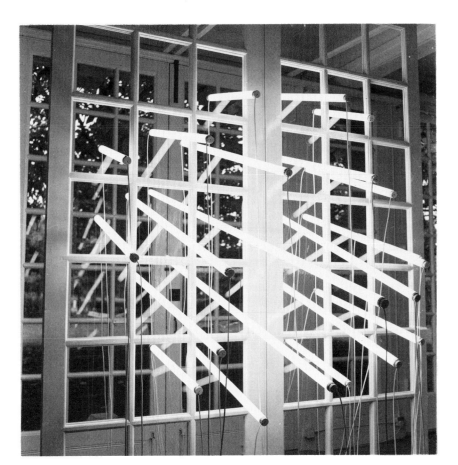

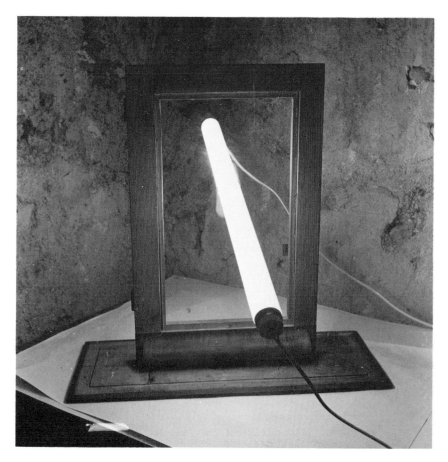

Window Light 1984
A two-foot fluorescent tube through a glass plane with a wooden frame and base.
50 × 55 × 58 cms
First shown Coracle, London 1984

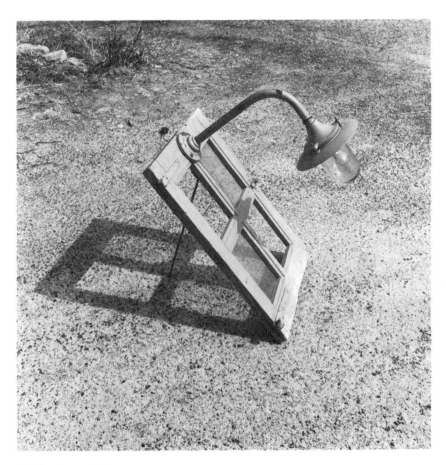

Window Lamp 1982
A cream painted window with a cream painted exterior lamp fitting. Glass weatherproofing over
the light bulb.
40 × 50 × 60 cms
First shown Winchester Art Gallery 1986

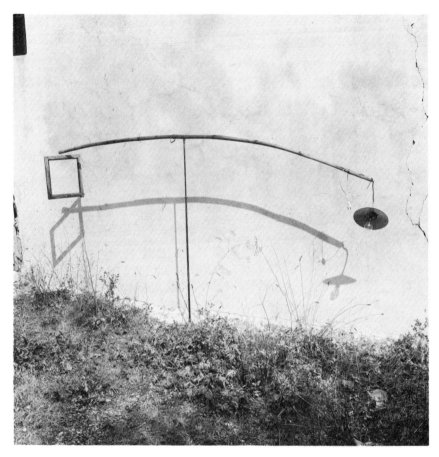

Window Mobile 1981
Prototype using natural light for the following installation.
France 1981

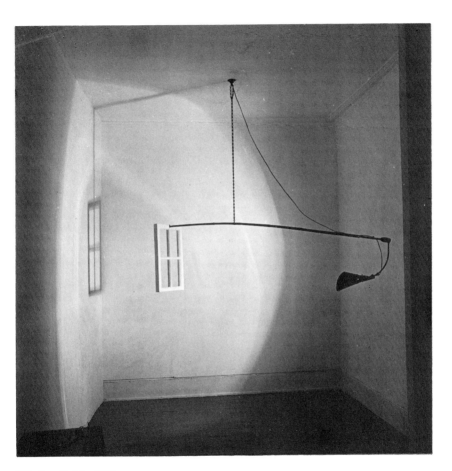

Window Mobile 1985
A white window frame with a black bamboo stick and a black reading lamp, suspended from the
ceiling by a metal chain. The slow movement of the mobile, projects the window shadow on the
wall at window height.
window 57 × 38 cms, length 200 cms
Installation: Interim Art, London 1985

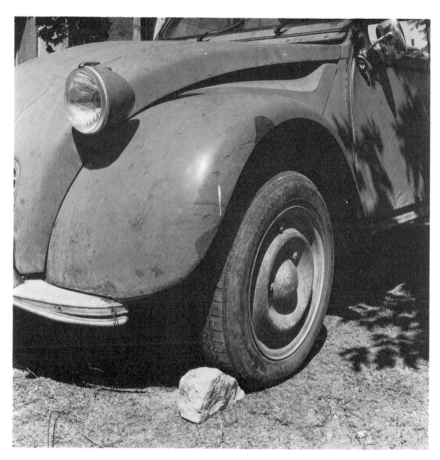

Car Sculpture I
France 1982

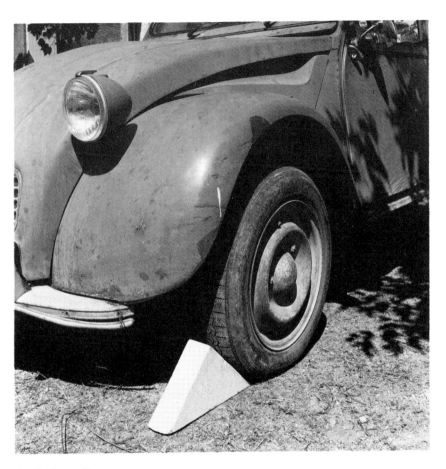

Car Sculpture II
France 1982

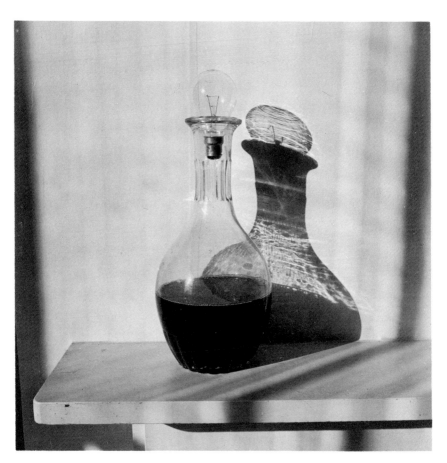

Decanter 1985
36 × 14 cms

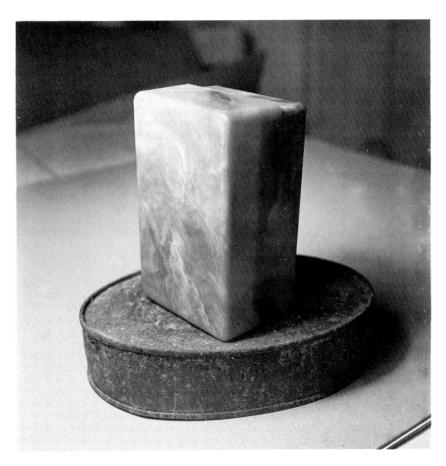

Jade II 1985
An emerald green semi-translucent plastic soap container on a rusty conserve tin base.
16 × 15 × 11 cms

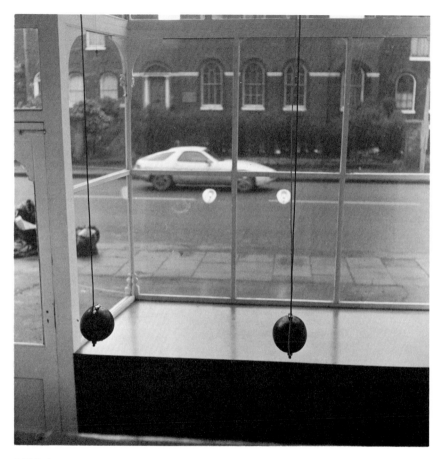

2 CV's I
Two grey 2CV headlamps with white painted interiors and 40 watt white light bulbs suspended by wiring from the ceiling and projecting onto the street.
Installation: Coracle, London 1985

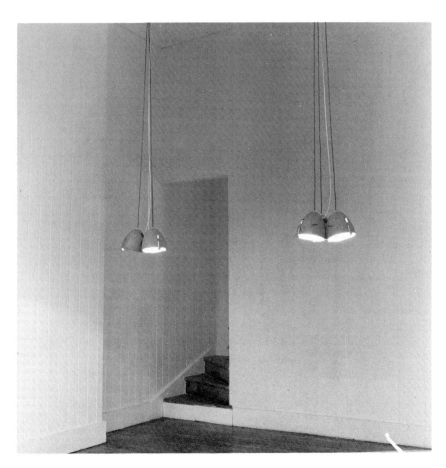

2 CV's II
Six 2CV headlamps as chandeliers.
Installation: Coracle, London 1985

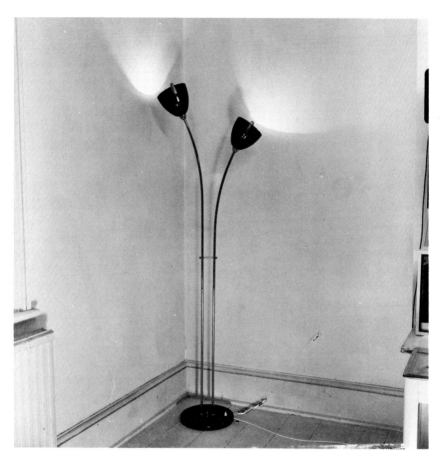

Standard I 1984
Two black 2CV headlamps on a brass and painted black standard lamp base. Red plastic indicator lights on lamps, the interiors white.
approx 5 feet high
First shown Coracle, London 1985

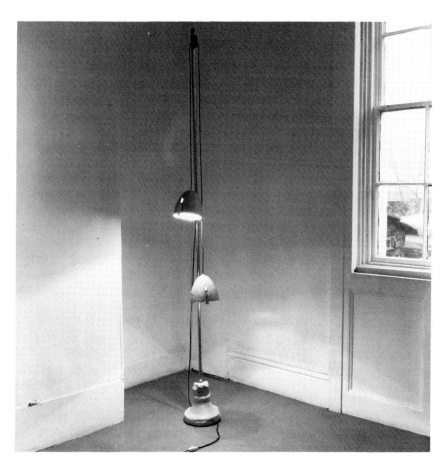

Standard II 1984
Two pale blue/grey 2CV headlamps suspended on wiring with an old metal pulley and hook fixed
onto a chromed metal tube supported by a marble base. The lamps are adjustable in height.
approx 5 feet high
First shown Coracle, London 1985

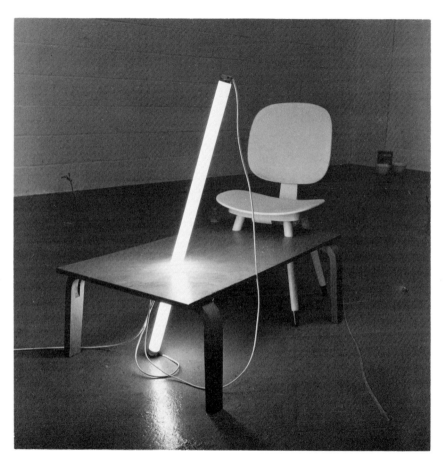

Nice I 1984
A low wood table with holes drilled to take the front legs of a painted white chair and a two-foot
fluorescent tube.
First shown Low-Tech, Coracle at Rees Martin Art Services, London 1984

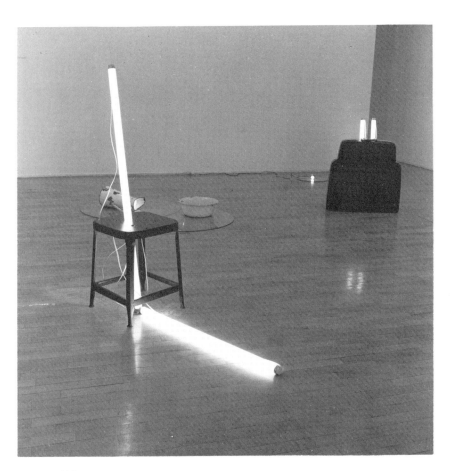

Aurora 1985
A black metal stool (trade mark 'Aurora', found on a dumpster in New York) with a four-foot and a three-foot fluorescent tube. The floor tube continues the vertical by its illusion of a reflection (broken five times during exhibition).
First shown Barbara Toll Fine Art, New York 1985

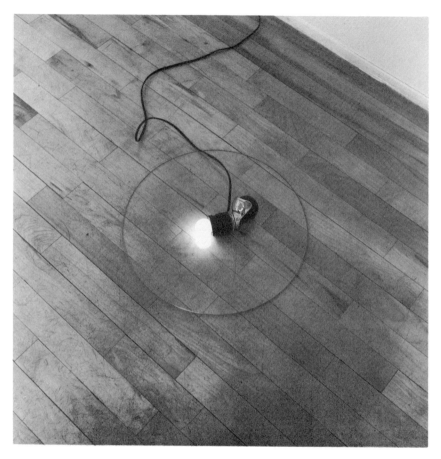

Boxed 1985
A small round light bulb and porcelain fitting fixed to a chrome caster with a spherical rubber wheel. Placed on a twelve-inch diameter circle of plate glass. Prototype for an edition.
First shown Barbara Toll Fine Art, New York 1985

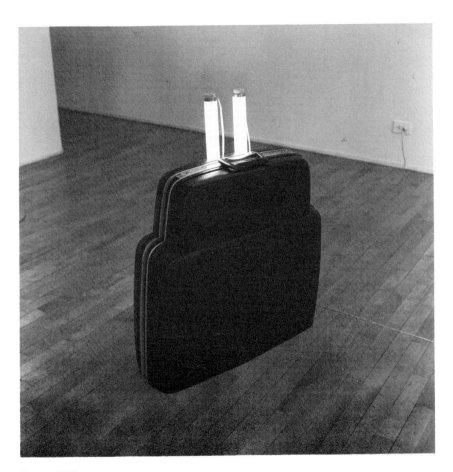

Dasher 1985
Two suitcases, the top cut from the larger one and the smaller pulled up through. The two fluorescent tubes stand vertically, the cases at a slight angle.
75 × 75 × 20 cms
First shown Barbara Toll Fine Art, New York 1985

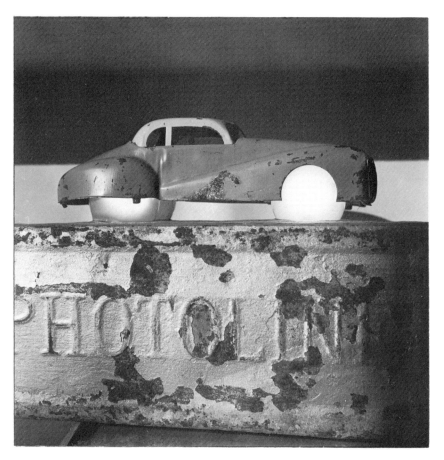

Custom Car 1 1985
A body of a green and cream toy car, the wheels are four small pearl light bulbs, the base an old French paraffin can with silver paint and rust.
14 × 21 × 46 cms

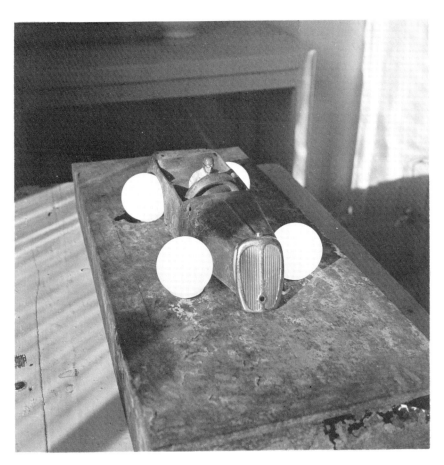

Custom Car II 1985
Customised from various toy cars, the wheels are four small white light bulbs, the base an old rusty biscuit tin.
18 × 15 × 36 cms

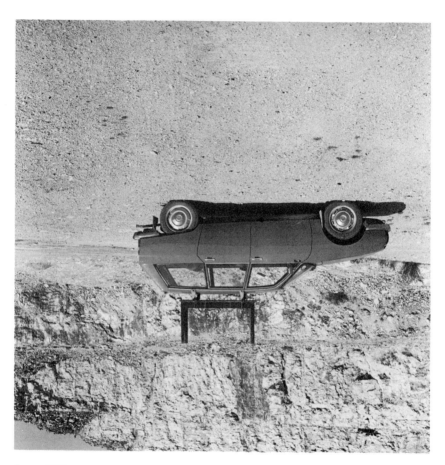

France 1985

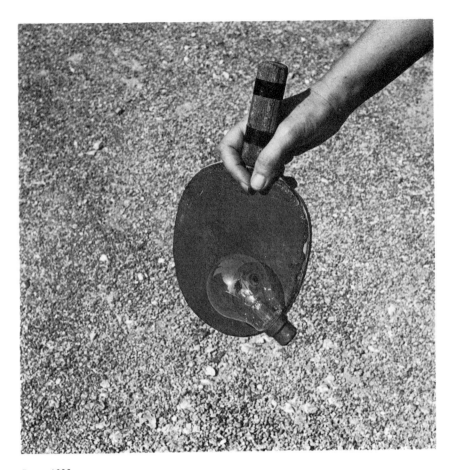

France 1985

We have sufficient authority in the Dutch school of art, for taking as subjects of representation scenes of daily and familiar occurrence . . . A casual gleam of sunshine, or a shadow thrown across his path, a time-withered oak, or a moss-covered stone may awake a train of thoughts and feelings, and picturesque imaginings.

W. H. Fox Talbot

Bill Culbert's work, as it has accumulated over the past eighteen years, bears the most evident marks of *genre*. The consistent procedure of photographing the individual objects, often in a simple domestic or garden setting, underlines this affiliation. We see his 'Shovel' propped up against a wooden table. A plastic flower-pot catches the light, while an adjacent bench is dappled with the shadows of foliage. Fox Talbot's famous photograph, 'The Open Door', presents a similarly poised garden implement—the broom, leaning against the stone door jamb, while dappled shadows and contrasts of light and shadow play across the differentiated surface of worn wood, burnished brass and white-washed wall. As Mike Weaver has pointed out, such a composition recalls us to the precedent of the Dutch genre painting of the seventeenth century: to Pieter de Hooch's 'A Courtyard in Delft', for example, where broom and pail are juxtaposed in careful combination, as the painting enacts its allegory of the opposition between the worldly and the spiritual life.

From Dutch genre, through early photography, to this body of contemporary work, the continuity is clear enough. Yet it can be thought of in two ways, the one strictly technical and the other emblematic. On the one technical level, the

starting point is no doubt the Dutch preoccupation with the devices of perspectival representation: mirrors, lenses, peepshows and the *camera obscura*. Svetlana Alpers has outlined in her remarkable study, *The Art of Describing,* that the Dutch painters of the seventeenth century rejected the narrative coherence of the Italian school in favour of a penetrating attention to the visual properties of objects, akin to the knowledge which contemporary scientists were acquiring through the microscope. A painter like Vermeer, as detailed modern research is beginning to show, steers a careful path between artifice and exactitude—the exact notations of space and light being 'given' by the device of a mediating screen whose minute nuances of focus he lovingly seeks to preserve in paint. For Fox Talbot, the unsuccessful draughtsman but accomplished amateur chemist, this technical feat is equalled if not surpassed by the innate properties of the light-responsive sheets of paper from which he prepares his calotypes. The 'camera' (no longer 'obscura') will restore a surplus of detail; what is more, the photographer will be able to experiment with 'mere variations in the fixing process, by means of which any tint, cold or warm, can be thrown over the picture'.

Bill Culbert's work adds to this sequence of specific, and wholly original, device; one might perhaps call it the hyperbolic representation of light. Very many artists, it need hardly be said, have made use of electric light in establishing their personal idiom. Frank Popper's highly informative *Electra* exhibition (Paris, 1983) ran through the range of this varied material, from the symbolic use of electricity by the modernist groups to the myriad uses of kinetic and computer-based artists of today. Bill Culbert was, one level, perfectly at home in his company. Yet his technique was, at the same time, directed to a uniquely specific end. He wrote at the time: 'I do not know of any other technical means

of realising *Small glass pouring light*. I want the work to be real. Electricity is used to change the image from itself (lightbulb) to a shadow which is a kind of reflection on itself. The glass of wine is the vehicle.' In other words, for Culbert the technique of electricity makes it possible to achieve a kind of self-transcendence for the object. This can be, and often is, a hyperbolic effect, as when the handle of a tool is replaced by neon tubing, becoming not merely the vehicle but the source of light. But it can also, by the same token, be an effect of litotes, of understatement. In 'Decanter', the glass container half-filled with wine is stopped with an electric light-bulb. However this light-bulb is not illuminated, except by the ambient light which 'pours' the lambent shadow of the decanter onto an adjacent wall, and singles out the bulb/stopper both as a vehicle and as a metonymy of luminosity.

About the emblematic significance of light, and the way it is manifested in these works, there is a great deal that could be said. De Hooch's 'A Courtyard in Delft' uses a simple domestic setting in order to set off against one another the image of the religious life—a young woman turning away from the spectator towards an interior, reserved space—and the image of contented domesticity—a second young woman giving her hand to a little child, who meets our eye more prominently. In the second, secular space, we find the broom and pail, which have combined to clean the spotless threshold. Yet this binary division between sacred and secular is overidden in the emblematic traditions of Western art, so that we can find a contemporary painter like the New Zealander Colin McCahon placing the homely objects adjacent to his Madonna and Child: 'The Blessed Virgin compared to a jug of pure water, and the Infant Jesus to a Lamp', runs the legend. Bill Culbert himself provides many examples of abrupt, even jarring juxtaposition, not least in the series of works

incorporating suitcases, where the luminous presence of the neon tube effaces the long history of the much travelled baggage. But his purest images alleviate this tension. In 'White Jug pouring Light', there is indeed a virginal quality, even a thematic expression of humble submission, in the outpouring of the light-filled vessel.

Walter Pater has epitomised better than any other writer that recurrent effect of presence, intimately associated with the manifestation of light, which the modernists called 'epiphany':

'A sudden light transfigures a trivial thing, a weather-vane, a windmill, a winnowing flail, the dust in the barn door: a moment—and the thing has vanished, because it was a pure effect: but it leaves a relish behind it, a longing that the accident may happen again'.

And, of course, it does happen again. It happens in the reading of Pater's prose, in the paintings of De Hooch and the photographs of Fox Talbot, and not least in the many-sided art of Bill Culbert.

Stephen Bann

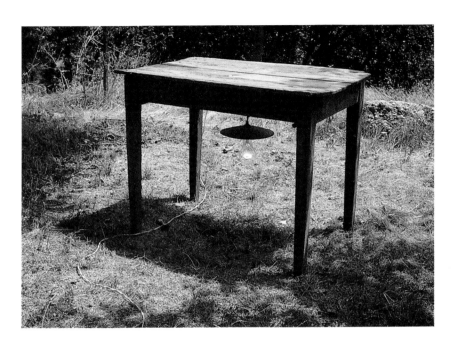

Table Lamp 1973

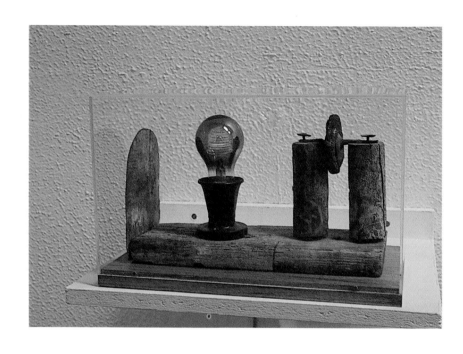

Wheel Works 1972

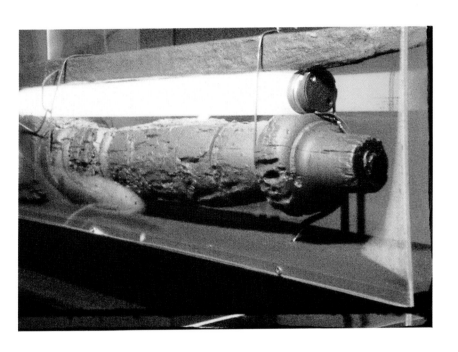

Murdering Beach 1978

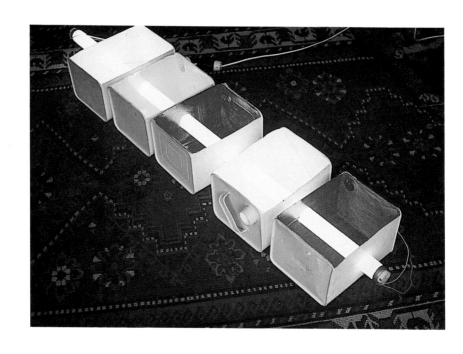

New Work 1978

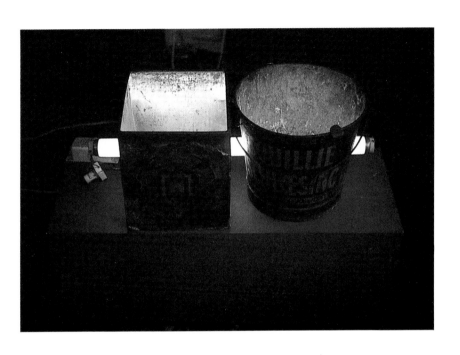

Tin Bucket and Box 1978

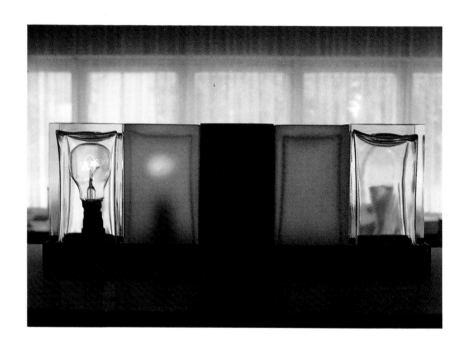

Daylight to Nightlight, Five Cubes to Black 1980

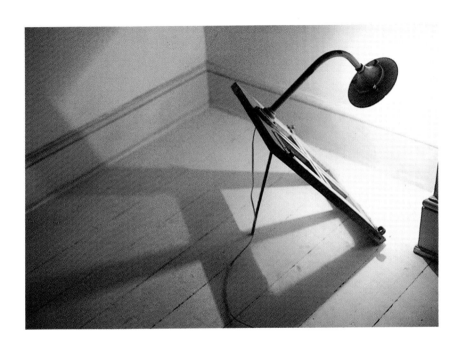

Window Light 1982

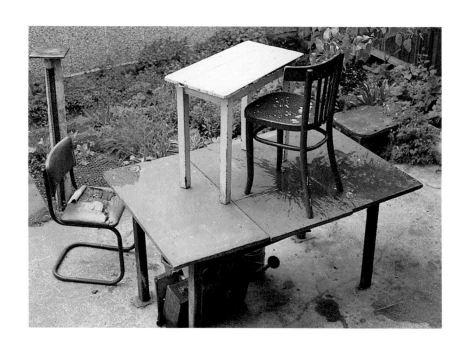

Lighthouse prototype 1985

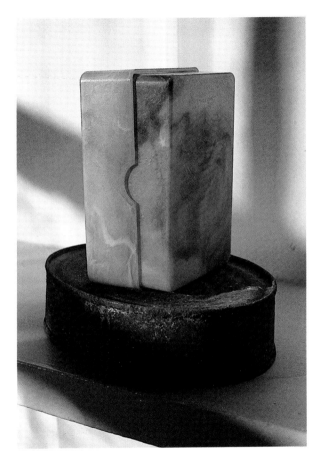

Jade II 1985

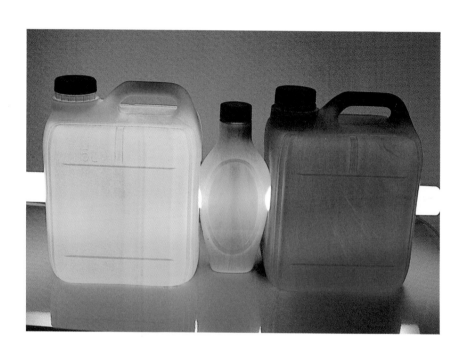

Jade 1985
2 foot tube

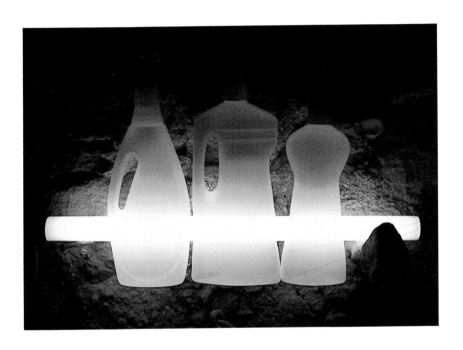

Mr Prop 1985
2 foot tube

Engine Room 1985
4 foot tube

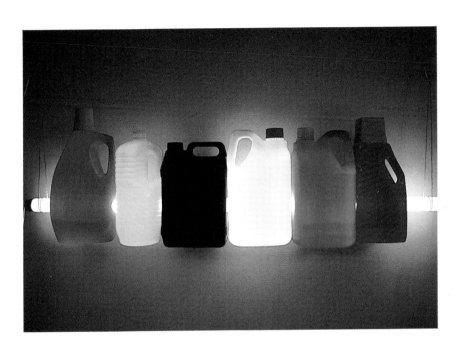

Tornado 1985
4 foot tube

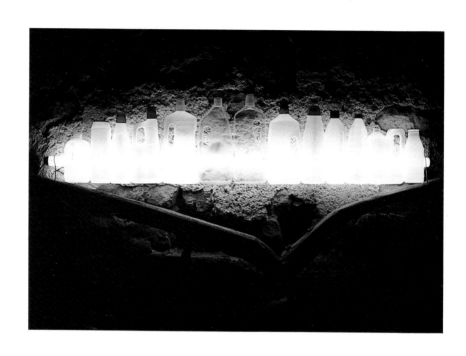

Long White Cloud 1985
5 foot tube

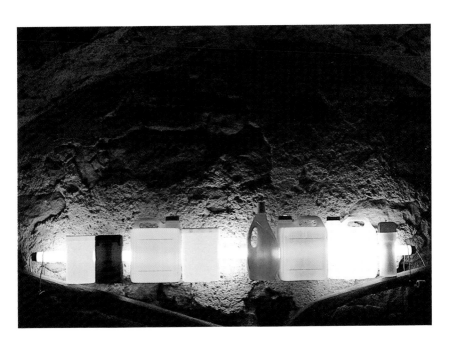

Banon 1985
5 foot tube

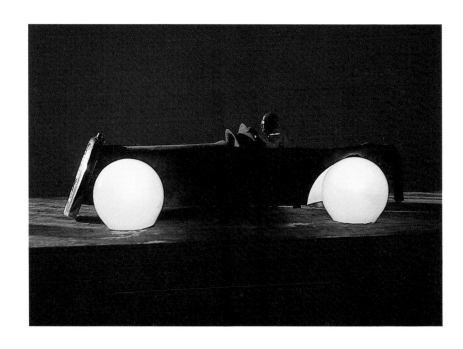

Custom Car 1 1985

William Franklin Culbert
Born 23 January 1935 Port Chalmers, New Zealand

Education
1948-52 Hutt Valley High School, New Zealand, under James Coe.
1953-56 Canterbury University School of Art. Diploma in Fine Art with Honours.
1957 Auckland Training College, New Zealand. Post Primary Teaching Certificate.
1957-60 Royal College of Art, London. ARCA with First Class Honours and Silver Medal for Painting.

One Artist Exhibitions
1961 Commonwealth Institute Art Gallery, London
 Edinburgh Festival, Scotland
1963 Nottingham University Art Gallery
 Hatton Art Gallery, Newcastle-on-Tyne
 Piccadilly Gallery, London
1964 Nottingham University Art Gallery
1965 McRoberts & Tunnard Gallery, London
1976 Forum Kunst Gallery, Rottweil, West Germany
1977 Serpentine Gallery, London
 Arts Council tour of Great Britain
 Walker Art Gallery, Liverpool
 DLI Gallery, Durham
 Mappin Art Gallery, Sheffield
 Bradford City Industrial Museum, Yorkshire
1978 Tour of New Zealand including National Art Gallery, Wellington
1979 Acme Gallery, London
1980 Sunderland Art Gallery
1982 Coracle, London
1984 Auckland City Art Gallery, New Zealand
1985 Coracle, London
1986 Atheneum, Dijon, France

Group Exhibitions
1955-56 Art Gallery, Christchurch, New Zealand
1959-60 The London Group
 The Young Contemporaries, London
1960-61 Young Commonwealth Artists, London
 Zwemmer Gallery London
1962 Piccadilly Gallery, London
1963 The Commonwealth Vision Group, London

	Towards Art, Royal College of Art, London
1964	Commonwealth Biennale Abstract Painting, London
	McRoberts & Tunnard Gallery, London
1967	K4, Brighton Festival and Museum of Modern Art, Oxford (in collaboration with Stuart Brisley)
1968	Light in Movement, touring Birmingham, Bristol, Coventry and Dublin (in collaboration with Stuart Brisley)
	Multiple: Cubic Projections, Lisson Gallery, London
	Survey 68, Camden Arts Centre, London (in collaboration with Stuart Brisley)
1969	A paraphrase of Rembrandt's 'Anatomy Lesson of Dr. Tulp' with the original at Rembrandt's Tri-centenary exhibition in Utrecht, Holland
	Five Light Artists, Greenwich Theatre Gallery, London
	British Movements, Berlin Germany
1970	Light Field, Arts Festival, Bristol University
1971	Multiples: The First Decade, Museum of Philadelphia, USA
1972	Multiples, Whitechapel Art Gallery, London
	Electric Gallery, Toronto, Canada
	Sculpture Multiples, ICA Gallery, London
1973	The Lucy Milton Gallery, London
1979-81	Forum Kunst Gallery, Rottweil, West Germany
1980-81	Licht in Westphalen, Ludenscheid, West Germany
1981	Tolly Cobbold Eastern Arts Third National, Cambridge and London
1981	GLAA Exhibition of Artists' Awards
	The South Bank Show, London
	The Holography Show, London
	Goldsmiths College Workshop touring exhibition
1983	The Sculpture Show, Serpentine and Hayward Galleries, London
	Drawing in Air, Sunderland Arts Centre
	Schaufelbagger und Muldenkipper, Coracle, London
	Assemble Here, Coracle in New York
	Electra, Musee de l'Art Moderne de la Ville de Paris
	Staircase Project, ICA, London
1984	pluXvalue, Eric Fabre Galerie, Paris
	Salon d'Automne, Coracle at the Serpentine Gallery, London
	Low-Tech, Coracle at Rees Martin Art Services, London
1985	Still Life, Barbara Toll Fine Art, New York
	Landscape Interior, Coracle, London
1986	Incidently, Winchester Art Gallery
	University of Reading Art Gallery

Awards

1957	New Zealand National Art Gallery Travelling Scholarship
1963-65	Fellow in Fine Art (resident artist), University of Nottingham
1964	First Prize, Open Painting Competition, Arts Council of Northern Ireland
1968	Prize, Open Painting Competition, Arts Council of Northern Ireland
1978	Visiting Fellow, Canterbury University, New Zealand
1981	Greater London Arts Association Award to Artists
1982	Arts Council of Great Britain Holographic Bursary
1985	Artist in Residence, Museum of Holography, New York

Commission

1970	Stage set design (Light Sculpture) for Ashton's ballet *'Lament of the Waves'* performed by the Royal Ballet at Covent Garden, London

Works in Public Collections

Aberdeen University
Arts Council of Great Britain
Arts Council of New Zealand
Arts Council of Northern Ireland
Carlisle Art Gallery
Castle Museum of Norwich
Contemporary Arts Society
Dowse Gallery, Lower Hutt, New Zealand
Govett-Brewster Gallery, New Plymouth, New Zealand
Hull Education Committee
Leckhampton House, Cambridge
Leicestershire County Collection
Manawatu Gallery, New Zealand
Manchester City Art Gallery
McDougall Art Gallery, Christchurch, New Zealand
National Art Gallery, Wellington, New Zealand
Nuffield Collection
West Riding of Yorkshire Education Committee

Publications

Bill Culbert, Serpentine Gallery, Arts Council of Great Britain, London 1977. Essay by David Thompson.
Bill Culbert, University of Canterbury Publishing Committee, New Zealand 1978. Essay by David Thompson.
Bill Culbert, Extant Work and Sources 1973—1984, Coracle Press, London 1984. Ninety-nine black and white photorahs.

'Tugs on Wall' Jan 8[...]

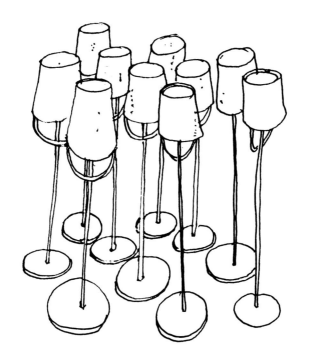

.FIELD

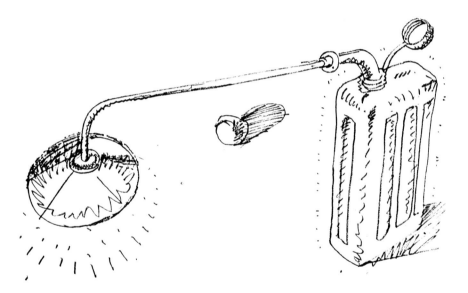

LAMP 1985 July.

'Light Tower'

Nov 5th
85

milk crate
on glass

9 nov 85

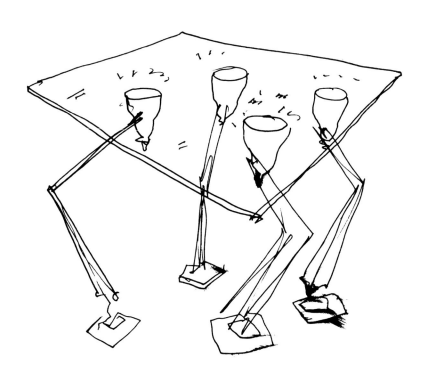

table Lamp 25 Oct 85

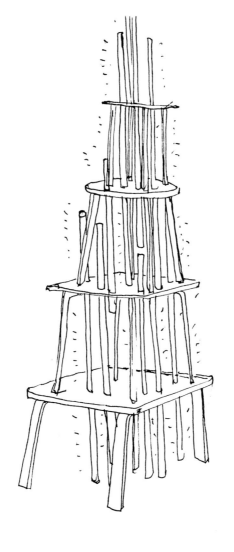

" LIGHT HOUSE ' I 1986 .

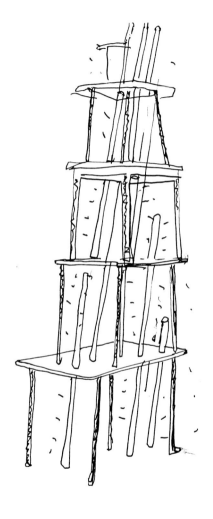

Space — " LIGHT HOUSE II " 20 Feb 82

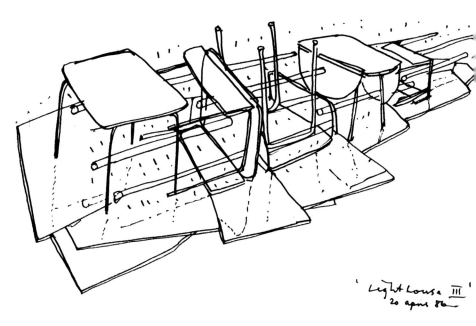

'Light House III'
20 april 86

Jhon

November 85.

The Institute of Contemporary Arts in an independent educational charity and while gratefully acknowledging the financial assistance of the Arts Council of Great Britain, Westminster City Council, The London Boroughs Grants Unit, and the British Film Institute, is primarily reliant on its box office income, memberships and donations.

Acting Exhibitions Director: James Lingwood
Associate Exhibitions Director: Andrea Schlieker
Gallery Manager: Stephen White
Gallery Assistant/Publications: James Peto
Director: Bill McAlister

Institute of Contemporary Arts, The Mall, London SW1

The Orchard Gallery (Derry City Council), Orchard Street, Derry BT48 6EG

Cornerhouse is supported by North West Arts, Manchester City Council, and the British Film Institute.

Exhibitions Director: Sue Grayson Ford

Cornerhouse, Greater Manchester Arts Centre Ltd, 70 Oxford Street, Manchester M1 5NH

Victoria Miro Gallery, 21 Cork Street, London W1

708/CUL

EXHIBCAT